Color
Mixing
Recipes
FOR WATERCOLOR

Mixing Recipes for More
Than 400 Color Combinations

By William F. Powell

www.walterfoster.com
Published by Walter Foster Publishing, Inc.
3 Wrigley, Suite A, Irvine, CA 92618

Contents

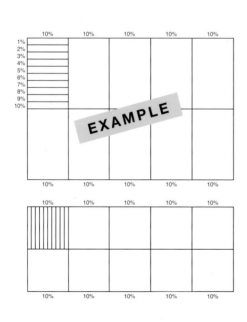

EXAMPLE

Turn to the back of
the book to find the
Color Mixing Grids!

This book is divided into six sections: **Color Theory** (pages 4–7), **Color Recipes** (pages 8–28), **Value Recipes** (pages 29–31), **Intensity Recipes** (pages 32–33), **Portrait Colors** (pages 34–37), and **Color Guidance Index** (pages 38–47). The paint colors needed for the recipes in this book are listed on the inside front cover. Be sure to read through the instructions and the Color Theory section before following the recipes in the other sections.

WATER DILUTION LEVELS

Each recipe in this book indicates a specific **Water Level**. The Water Level indicates whether the mixture should be heavily diluted with water, which makes the color's intensity lighter and paler, or lightly diluted, which makes it darker and stronger. **Level 1** is the thinnest, lightest intensity and requires the greatest amount of water. **Level 2** also is thin and light but calls for slightly less water than Level 1. **Level 3** is medium intensity, requiring less water than Level 2. **Level 4** is strong intensity, using just a small amount of water. **Level 5** is the strongest intensity and needs little or no water. See the key at right for Water Level samples.

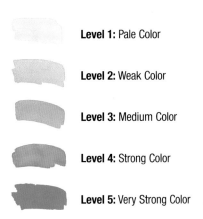

Level 1: Pale Color

Level 2: Weak Color

Level 3: Medium Color

Level 4: Strong Color

Level 5: Very Strong Color

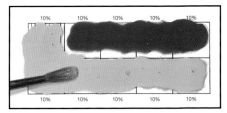

FILLING THE SQUARES As you're measuring the paint on the grid (in this case, 60% cadmium yellow and 40% sap green), leave a bit of room between the colors to keep them from running into one another.

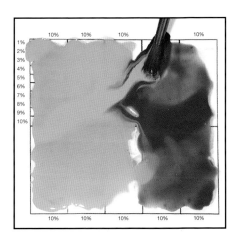

USING THE GRID AS A PALETTE Once you've finished measuring the paints on the grid, simply pull the colors together and mix them with your brush.

MEASURING THE COLORS

Use the plastic **Color Mixing Grids** at the back of this book to measure the proper amounts of paint for each recipe. The large grid is for mixing large amounts of color; the small grid is for small amounts. Each grid is composed of ten rectangles, with each rectangle representing 10% of the total mix. (So, for example, if the recipe calls for 60% cadmium yellow and 40% sap green, you would mix 6 rectangles of cadmium yellow with 4 rectangles of sap green. See examples at left.) When less than 10% of a color is needed, use the smaller sections of the first rectangle on the applicable grid.

Some recipes call for a **drop** of paint, which is less than 1% of the mix (about the size of a small bead of water). When using the large grid, a drop always should be Water Level 5 (see "Water Dilution Levels" above); when using the small grid, a drop always should be Level 4.

MIXING THE PAINT ON THE GRIDS

To use the grids, first dilute each recipe color to the indicated Water Level. Next use a wet paintbrush to pull the diluted colors onto the grid in the suggested ratios. Then mix the colors on the grid to achieve the desired color. Rinse and wipe the plastic grid clean when finished.

ColorTheory

There are three things to consider when mixing colors: hue, value, and intensity (also known as **chroma**). **Hue** refers to the name of a pure color; **value** refers to the lightness or darkness of a color or of black; and **intensity** refers to the brightness or dullness of a color.

MIXING HUES (Pages 8–28)

There are three **primary** colors (hues): yellow, red, and blue. All other colors are derived from these three hues.

| YELLOW | RED | BLUE |

Mixing primary colors together results in a **secondary** color, as shown below.

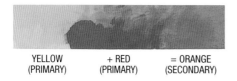

| YELLOW | + RED | = ORANGE |
| (PRIMARY) | (PRIMARY) | (SECONDARY) |

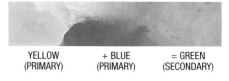

| YELLOW | + BLUE | = GREEN |
| (PRIMARY) | (PRIMARY) | (SECONDARY) |

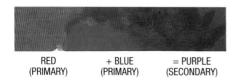

| RED | + BLUE | = PURPLE |
| (PRIMARY) | (PRIMARY) | (SECONDARY) |

The secondary colors—orange, green, and purple—can be mixed with one another or any of the primary colors to create other colors.

Mixing a primary color—yellow, red, or blue—with a secondary color—orange, green, or purple—results in a third group known as **tertiary** colors. After mixing these colors, you can make a basic chart containing 12 major color groups. This **color wheel** can be used as a working tool and reference guide for mixing colors and creating color palettes.

MIXING VALUES (Pages 29–31)

On the color wheel, yellow has the lightest value and purple has the darkest value. Notice that the colors change in value, becoming lighter as they move up the color wheel and darker as they move down the color wheel.

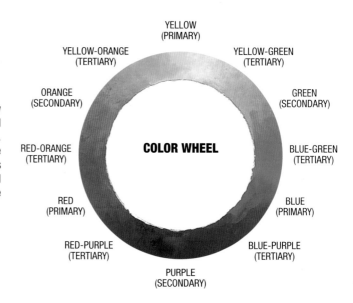

YELLOW
(PRIMARY)

YELLOW-ORANGE
(TERTIARY)

YELLOW-GREEN
(TERTIARY)

ORANGE
(SECONDARY)

GREEN
(SECONDARY)

RED-ORANGE
(TERTIARY)

COLOR WHEEL

BLUE-GREEN
(TERTIARY)

RED
(PRIMARY)

BLUE
(PRIMARY)

RED-PURPLE
(TERTIARY)

BLUE-PURPLE
(TERTIARY)

PURPLE
(SECONDARY)

MIXING TINTS, TONES, AND SHADES (Pages 29–31)

Color is a phenomenon of light; without light there is no color. On the scale of white through gray to black, white is considered to be "light" and black is considered to be "dark." Dark is the absence of light and, therefore, the absence of color. When using paints in an opaque manner (as with thick oil or acrylic), you can lighten colors by adding an opaque white pigment such as titanium white. In the early days of watercolor, the pigments were used in an opaque manner. Today, however, watercolor is considered a "transparent" medium, and paints are used in varying degrees of thin layers and **washes** (paint diluted with water). In transparent watercolor painting, the paper serves as the "white," and varying degrees of value are achieved by adding or withholding water. The more water added, the more the white of the painting surface shows through, and the thinner and weaker the color.

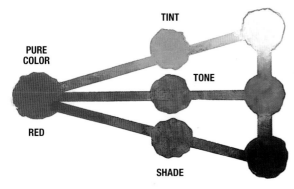

Adding water to any watercolor weakens the color, resulting in a **tint** of that color.

Adding gray to any color results in a **tone** of that color.

Adding black to any color results in a **shade** of that color.

In transparent watercolor painting, mixing water with black in varying amounts creates a variety of grays known as the **value scale.** When a color is mixed with black, it is a **cool value** mix. A **warm value** mix can be made by using a dark, warm color, such as burnt umber, or a mix of burnt umber and ultramarine blue.

A painting done solely in white, black, and different values of gray is called an **achromatic** painting.

A painting done with tints, tones, and shades (along with various intensities) of a single color is a **monochromatic** painting.

KEEPING COLOR MIXES FRESH AND LIVELY WHEN TINTING AND SHADING

Keep color mixes "fresh" by following the two simple rules shown below.

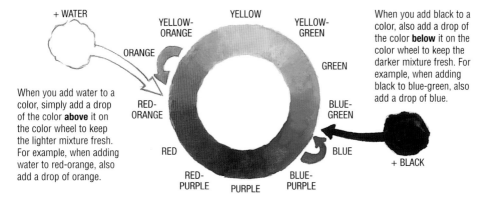

When you add water to a color, simply add a drop of the color **above** it on the color wheel to keep the lighter mixture fresh. For example, when adding water to red-orange, also add a drop of orange.

When you add black to a color, also add a drop of the color **below** it on the color wheel to keep the darker mixture fresh. For example, when adding black to blue-green, also add a drop of blue.

Whenever you add water or black to a watercolor mix, the extra color from either above or below the color should be close to the selected color on the wheel. If you choose a color that is too far away, you will make a new color. The two colors should be analogous. (Colors that resemble one another but are slightly different and are close to one another on the color wheel are called **analogous** colors.)

ColorTheory

INTENSITY OR CHROMA

Bright colors, such as cadmium orange, are considered more **chromatic** or intense than dull colors, such as burnt umber. The brighter, more chromatic colors are on the outer edge of the color wheel; the duller, less chromatic colors are on the inner circles. Notice that burnt umber (a less chromatic color) is a member of the yellow-orange family and that it is a complement to blue. It is important to know where each color fits on the color wheel.

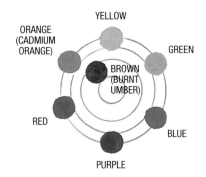

GRAYING COLORS NATURALLY (Pages 32–33)

As explained on page 5, adding black, water, or gray to a watercolor mix results in shades, tints, and tones, respectively. This does not, however, produce a "natural" graying of colors. To obtain beautiful, **natural grays** of colors, you can use the color wheel and the following rules regarding complements.

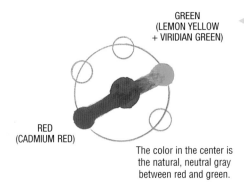

GREEN
(LEMON YELLOW + VIRIDIAN GREEN)

RED
(CADMIUM RED)

The color in the center is the natural, neutral gray between red and green.

MIXING DIRECT COMPLEMENTS

As shown at left, two colors that are directly across from each other on the color wheel are called **direct complements.** Direct complements can neutralize (gray) one another better than any other colors on the wheel. Mixing varying amounts of each color creates a natural graying of each color. (See the charts on pages 32 and 33.)

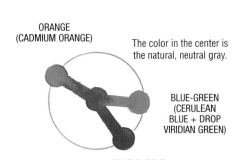

ORANGE
(CADMIUM ORANGE)

The color in the center is the natural, neutral gray.

BLUE-GREEN
(CERULEAN BLUE + DROP VIRIDIAN GREEN)

BLUE-PURPLE
(ULTRAMARINE BLUE + DROP PERMANENT ALIZARIN CRIMSON)

MIXING SPLIT COMPLEMENTS

Using the colors on each side of a color's direct complement provides a wider range of color mixes and a variety of neutral grays, as shown at right. This is known as a **split complement** mixture.

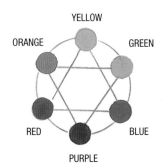

YELLOW

ORANGE GREEN

RED BLUE

PURPLE

MIXING TRIADS

As shown at left, a combination of any three colors equally distant from one another on the color wheel is known as a **triad.** A triad allows for a broader range of color mixes yet maintains a true color harmony. Move the triad clockwise to the next three colors to produce a different combination of colors.

WARM AND COOL COLORS

Generally, colors on the left side of the wheel (with the red family of colors) are considered **warm** colors, and colors on the right side of the wheel (with the blue family of colors) are considered **cool** colors.

Within all families of colors, however, there are both warm and cool hues. For instance, a blue that contains more red (purplish blue) is warmer than a blue that contains yellow (greenish blue). On the other side of the wheel, a red that contains more blue (purplish red) is cooler than a red that contains yellow (orangish red).

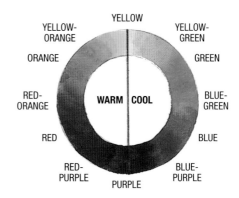

KEY COLOR HARMONY

The **key color** is the dominant color in a painting or in several different color mixtures. The key color sometimes is referred to as the **mother color** because a bit of the color is added to all the mixtures to create color unity and harmony.

COLOR PSYCHOLOGY

Color psychology is a rather complex subject. Color affects our reactions, emotions, and feelings. Different people, however, may react differently to the same color or colors. For example, red may be a favorite color for some, blue or green for others. A few simple points on color psychology and the typical reactions to certain colors are illustrated below.

Dark colors, such as purples and deep blues, are considered moody or sometimes even threatening.

Light, bright colors usually are considered pleasant colors. If they aren't too bright, they are comfortable to view.

When bright, raw colors are placed next to one another, they appear loud, gaudy, and harsh. This is demonstrated here with the combination of blue, red, and green.

HIGH KEY AND LOW KEY USE OF COLOR

A painting that contains a lot of white and can be compared to the lighter end of the value scale is called a **high key** painting. A painting that contains a lot of black and darks and can be compared to the darker end of the value scale is called a **low key** painting.

For a more in-depth study of color and color theory, see *Beginner's Guide: Color* (HT56) in Walter Foster's How to Draw and Paint series and *Color and How to Use It* (AL05) in the Artist's Library series, both by William F. Powell.

ColorRecipes

 Cadmium Yellow Light

Cadmium Yellow Medium

Naples Yellow

1. 25% cadmium yellow light
 75% Naples yellow
 Water Level 1

2. 95% cadmium yellow medium
 5% Naples yellow
 Water Level 1

3. 100% cadmium yellow light
 Water Level 1

4. 25% cadmium yellow light
 75% Naples yellow
 Water Level 1.5

5. 95% cadmium yellow medium
 5% Naples yellow
 Water Level 1.5

6. 100% cadmium yellow light
 Water Level 1.5

7. 25% cadmium yellow light
 75% Naples yellow
 Water Level 2

8. 95% cadmium yellow medium
 5% Naples yellow
 Water Level 1.75

9. 100% cadmium yellow light
 Water Level 1.75

10. 25% cadmium yellow light
 75% Naples yellow
 Water Level 2.5

11. 95% cadmium yellow medium
 5% Naples yellow
 Water Level 2

12. 100% cadmium yellow light
 Water Level 2.5

13. 25% cadmium yellow light
 75% Naples yellow
 Water Level 3

14. 95% cadmium yellow medium
 5% Naples yellow
 Water Level 3

15. 100% cadmium yellow light
 Water Level 3

| **COLORS** USED | Cadmium Yellow Light |
| Lemon Yellow |
| Cerulean Blue |

16. 90% cadmium yellow light
10% lemon yellow
Water Level 2.5

17. 100% cadmium yellow light
Water Level 3.5

18. 100% cadmium yellow light
Water Level 5

19. 30% cadmium yellow light
65% lemon yellow
5% cerulean blue
Water Level 2

20. 70% cadmium yellow light
15% lemon yellow
15% cerulean blue
Water Level 3

21. 70% cadmium yellow light
20% lemon yellow
10% cerulean blue
Water Level 2.5

22. 10% cadmium yellow light
65% lemon yellow
25% cerulean blue
Water Level 2.5

23. 60% cadmium yellow light
15% lemon yellow
25% cerulean blue
Water Level 3

24. 65% cadmium yellow light
5% lemon yellow
30% cerulean blue
Water Level 3

25. 5% cadmium yellow light
70% lemon yellow
25% cerulean blue
Water Level 3

26. 10% cadmium yellow light
60% lemon yellow
30% cerulean blue
Water Level 3

27. 10% cadmium yellow light
70% lemon yellow
20% cerulean blue
Water Level 3.5

28. 5% cadmium yellow light
65% lemon yellow
30% cerulean blue
Water Level 3.5

29. 60% cadmium yellow light
5% lemon yellow
35% cerulean blue
Water Level 3

30. 20% lemon yellow
80% cerulean blue
Water Level 4

ColorRecipes

31. 65% lemon yellow
35% cadmium yellow light
Water Level 1

32. 65% lemon yellow
35% cadmium yellow light
Water Level 2

33. 65% lemon yellow
35% cadmium yellow light
Water Level 3.5

34. 88% lemon yellow
10% cadmium yellow light
2% phthalo blue
Water Level 2

35. 75% lemon yellow
20% cadmium yellow light
5% phthalo blue
Water Level 2

36. 75% lemon yellow
20% cadmium yellow light
5% phthalo blue
Water Level 2.5

37. 85% lemon yellow
10% cadmium yellow light
5% phthalo blue
Water Level 2.5

38. 80% lemon yellow
15% cadmium yellow light
5% phthalo blue
Water Level 2.5

39. 80% lemon yellow
15% cadmium yellow light
5% phthalo blue
Water Level 3

40. 85% lemon yellow
10% cadmium yellow light
5% phthalo blue
Water Level 3

41. 80% lemon yellow
10% cadmium yellow light
10% phthalo blue
Water Level 3

42. 50% lemon yellow
35% cadmium yellow light
15% phthalo blue
Water Level 3

43. 70% lemon yellow
10% cadmium yellow light
20% phthalo blue
Water Level 3.5

44. 60% lemon yellow
10% cadmium yellow light
30% phthalo blue
Water Level 4

45. 20% lemon yellow
30% cadmium yellow light
50% phthalo blue
Water Level 4

COLORS USED

 Gamboge
 Raw Sienna
Viridian Green
Permanent Rose
Cadmium Yellow Deep
Cadmium Red Light
Cobalt Blue

46. 80% gamboge
20% raw sienna
Water Level 1

47. 80% gamboge
20% raw sienna
Water Level 2

48. 80% gamboge
20% raw sienna
Water Level 3

49. 80% gamboge
19% raw sienna
1% viridian green
Water Level 1

50. 80% gamboge
19% raw sienna
1% viridian green
Water Level 2

51. 80% gamboge
19% raw sienna
1% viridian green
Water Level 3

52. 98% gamboge
2% viridian green
Water Level 1

53. 95% gamboge
5% viridian green
Water Level 2

54. 90% gamboge
5% raw sienna
5% viridian green
Water Level 3

55. 30% gamboge
68% viridian green
2% permanent rose
Water Level 2.5

56. 35% cadmium yellow deep
60% viridian green
5% cadmium red light
Water Level 3

57. 30% cadmium yellow deep
60% viridian green
10% permanent rose
Water Level 3

58. 20% cadmium yellow deep
60% viridian green
20% cobalt blue
Water Level 3

59. 20% cadmium yellow deep
55% viridian green
25% cobalt blue
Water Level 3

60. 20% cadmium yellow deep
55% viridian green
25% cobalt blue
Water Level 4

ColorRecipes

61. 50% cadmium orange
50% cadmium red light
Water Level 1

62. 50% cadmium orange
50% cadmium red light
Water Level 2

63. 50% cadmium orange
50% cadmium red light
Water Level 3

64. 40% cadmium orange
60% cadmium red light
Water Level 1

65. 40% cadmium orange
60% cadmium red light
Water Level 2

66. 30% cadmium orange
70% cadmium red light
Water Level 2.5

67. 60% Naples yellow
30% cadmium orange
10% cerulean blue
Water Level 2

68. 60% Naples yellow
25% cadmium orange
15% cerulean blue
Water Level 3

69. 50% Naples yellow
10% cadmium orange
40% burnt umber
Water Level 3

70. 30% cerulean blue
60% Naples yellow
10% cadmium orange
Water Level 3

71. 60% cerulean blue
30% Naples yellow
7% cadmium orange
3% cadmium yellow deep
Water Level 3

72. 60% cerulean blue
20% Naples yellow
10% ultramarine blue
10% cadmium yellow deep
Water Level 3.5

73. 60% cerulean blue
40% cadmium yellow deep
Water Level 3

74. 80% cerulean blue
15% cadmium orange
5% cadmium yellow deep
Water Level 3

75. 80% cerulean blue
10% cadmium orange
10% phthalo blue
Water Level 3

 Gamboge Phthalo Blue

 Raw Sienna Burnt Sienna

 Burnt Umber Lemon Yellow

76. 85% gamboge
15% raw sienna
Water Level 1

77. 80% raw sienna
20% burnt umber
Water Level 2

78. 75% raw sienna
25% burnt umber
Water Level 3

79. 80% gamboge
10% raw sienna
10% phthalo blue
Water Level 1

80. 75% raw sienna
15% phthalo blue
10% gamboge
Water Level 2

81. 65% raw sienna
15% burnt sienna
20% phthalo blue
Water Level 3

82. 80% lemon yellow
10% raw sienna
10% phthalo blue
Water Level 2

83. 60% lemon yellow
20% raw sienna
20% phthalo blue
Water Level 3

84. 70% raw sienna
30% phthalo blue
Water Level 3

85. 95% phthalo blue
5% lemon yellow
Water Level 2

86. 90% phthalo blue
5% raw sienna
5% lemon yellow
Water Level 3

87. 95% phthalo blue
5% raw sienna
Water Level 4

88. 100% phthalo blue
2 drops lemon yellow
Water Level 2

89. 100% phthalo blue
3 drops raw sienna
Water Level 3

90. 100% phthalo blue
Water Level 4

ColorRecipes

● Phthalo Blue

● Burnt Umber

Lemon Yellow

● Yellow Ochre

● Burnt Sienna

○ Naples Yellow

91. 1 drop recipe #105
1 drop lemon yellow
Water Level 1

92. 100% phthalo blue
1 drop yellow ochre
Water Level 1

93. 98% phthalo blue
2% yellow ochre
Water Level 1

94. 60% lemon yellow
40% recipe #105
Water Level 1

95. 90% phthalo blue
10% burnt sienna
Water Level 2

96. 95% phthalo blue
5% burnt umber
Water Level 2

97. 70% lemon yellow
30% recipe #105
Water Level 2

98. 60% phthalo blue
40% Naples yellow
Water Level 2

99. 80% phthalo blue
20% burnt umber
Water Level 3

100. 65% lemon yellow
35% recipe #105
Water Level 2

101. 65% phthalo blue
35% yellow ochre
Water Level 3

102. 70% phthalo blue
30% burnt umber
Water Level 3

103. 65% lemon yellow
35% recipe #105
Water Level 3

104. 80% phthalo blue
20% yellow ochre
Water Level 4

105. 40% phthalo blue
60% burnt umber
Water Level 4.5

COLORS USED	Viridian Green
	Phthalo Blue

106. 75% viridian green
25% phthalo blue
Water Level 1

107. 50% viridian green
50% phthalo blue
Water Level 1

108. 100% phthalo blue
Water Level 1

109. 80% viridian green
20% phthalo blue
Water Level 2

110. 50% viridian green
50% phthalo blue
Water Level 2

111. 100% phthalo blue
Water Level 2

112. 85% viridian green
15% phthalo blue
Water Level 2.5

113. 50% viridian green
50% phthalo blue
Water Level 2.5

114. 100% phthalo blue
Water Level 2.5

115. 85% viridian green
15% phthalo blue
Water Level 3

116. 50% viridian green
50% phthalo blue
Water Level 3

117. 100% phthalo blue
Water Level 3

118. 90% viridian green
10% phthalo blue
Water Level 3.5

119. 50% viridian green
50% phthalo blue
Water Level 3.5

120. 100% phthalo blue
Water Level 3.5

ColorRecipes

121. 100% cerulean blue
Water Level 1

122. 60% cerulean blue
40% ultramarine blue
Water Level 1

123. 100% ultramarine blue
Water Level 1

124. 100% cerulean blue
Water Level 2

125. 60% cerulean blue
40% ultramarine blue
Water Level 2

126. 95% ultramarine blue
5% permanent rose
Water Level 2

127. 98% cerulean blue
2% viridian green
Water Level 2.5

128. 60% cerulean blue
40% ultramarine blue
Water Level 3

129. 95% ultramarine blue
5% permanent rose
Water Level 3

130. 95% cerulean blue
5% viridian green
Water Level 3

131. 60% cerulean blue
40% ultramarine blue
Water Level 3.5

132. 95% ultramarine blue
5% permanent rose
Water Level 4

133. 90% cerulean blue
5% viridian green
5% ultramarine blue
Water Level 4

134. 50% cerulean blue
50% ultramarine blue
Water Level 4

135. 95% ultramarine blue
5% permanent rose
Water Level 5

COLORS USED

● Ultramarine Blue

● Permanent Alizarin Crimson

● Burnt Umber

136. 100% ultramarine blue
Water Level 1

137. 96% ultramarine blue
2% permanent alizarin crimson
2% burnt umber
Water Level 2

138. 98% ultramarine blue
2% permanent alizarin crimson
Water Level 3.5

139. 95% ultramarine blue
4% permanent alizarin crimson
1% burnt umber
Water Level 1

140. 85% ultramarine blue
10% permanent alizarin crimson
5% burnt umber
Water Level 2.5

141. 95% ultramarine blue
4% permanent alizarin crimson
1% burnt umber
Water Level 2.5

142. 95% ultramarine blue
2% permanent alizarin crimson
3% burnt umber
Water Level 2.5

143. 80% ultramarine blue
20% permanent alizarin crimson
Water Level 2.5

144. 90% ultramarine blue
7% permanent alizarin crimson
3% burnt umber
Water Level 2.5

145. 95% ultramarine blue
3% permanent alizarin crimson
2% burnt umber
Water Level 3

146. 80% ultramarine blue
15% permanent alizarin crimson
5% burnt umber
Water Level 3.5

147. 45% ultramarine blue
20% permanent alizarin crimson
35% burnt umber
Water Level 4

148. 95% ultramarine blue
4% permanent alizarin crimson
1% burnt umber
Water Level 4

149. 85% ultramarine blue
10% permanent alizarin crimson
5% burnt umber
Water Level 4

150. 45% ultramarine blue
30% permanent alizarin crimson
25% burnt umber
Water Level 5

ColorRecipes

COLORS USED

⬤ Ultramarine Blue

⬤ Cerulean Blue

⬤ Permanent Rose

151. 80% ultramarine blue
20% cerulean blue
Water Level 1

152. 60% ultramarine blue
30% cerulean blue
10% permanent rose
Water Level 1

153. 75% ultramarine blue
15% cerulean blue
10% permanent rose
Water Level 1

154. 80% ultramarine blue
20% cerulean blue
Water Level 2

155. 60% ultramarine blue
20% cerulean blue
20% permanent rose
Water Level 2

156. 50% ultramarine blue
20% cerulean blue
30% permanent rose
Water Level 2

157. 90% ultramarine blue
10% cerulean blue
Water Level 2.5

158. 70% ultramarine blue
25% cerulean blue
5% permanent rose
Water Level 2.5

159. 55% ultramarine blue
20% cerulean blue
25% permanent rose
Water Level 2.5

160. 90% ultramarine blue
10% cerulean blue
Water Level 3

161. 75% ultramarine blue
20% cerulean blue
5% permanent rose
Water Level 3

162. 70% ultramarine blue
25% cerulean blue
5% permanent rose
Water Level 3

163. 100% ultramarine blue
Water Level 4

164. 75% ultramarine blue
20% cerulean blue
5% permanent rose
Water Level 3

165. 80% ultramarine blue
15% cerulean blue
5% permanent rose
Water Level 4

ColorRecipes

COLORS USED

● Cobalt Blue ● Permanent Rose

● Permanent Alizarin Crimson

● Ultramarine Blue

166. 60% cobalt blue
40% permanent alizarin crimson
Water Level 1

167. 35% cobalt blue
65% permanent alizarin crimson
Water Level 1

168. 25% ultramarine blue
75% permanent rose
Water Level 1

169. 65% cobalt blue
35% permanent alizarin crimson
Water Level 2

170. 40% cobalt blue
60% permanent alizarin crimson
Water Level 2

171. 25% ultramarine blue
75% permanent rose
Water Level 2

172. 75% cobalt blue
25% permanent alizarin crimson
Water Level 2.5

173. 40% cobalt blue
60% permanent alizarin crimson
Water Level 3

174. 25% ultramarine blue
75% permanent rose
Water Level 2.5

175. 75% cobalt blue
25% permanent alizarin crimson
Water Level 3

176. 45% cobalt blue
55% permanent alizarin crimson
Water Level 3

177. 25% ultramarine blue
75% permanent rose
Water Level 3

178. 80% cobalt blue
20% permanent alizarin crimson
Water Level 3.5

179. 50% cobalt blue
50% permanent alizarin crimson
Water Level 3.5

180. 30% ultramarine blue
70% permanent rose
Water Level 3.5

19

ColorRecipes

COLORS USED

● Permanent Rose

● Cobalt Blue

● Permanent Alizarin Crimson

181. 100% permanent rose
2 drops cobalt blue
Water Level 2

182. 100% permanent rose
Water Level 1

183. 99% permanent alizarin crimson
1% permanent rose
Water Level 1

184. 100% permanent rose
2 drops cobalt blue
Water Level 2.5

185. 100% permanent rose
Water Level 2

186. 65% permanent alizarin crimson
35% permanent rose
Water Level 2

187. 100% permanent rose
3 drops cobalt blue
Water Level 3

188. 100% permanent rose
Water Level 3

189. 55% permanent alizarin crimson
45% permanent rose
Water Level 3

190. 90% permanent rose
6% permanent alizarin crimson
4% cobalt blue
Water Level 2

191. 100% permanent rose
Water Level 3.5

192. 50% permanent alizarin crimson
50% permanent rose
Water Level 3.5

193. 80% permanent rose
15% permanent alizarin crimson
5% cobalt blue
Water Level 4

194. 100% permanent rose
Water Level 4

195. 60% permanent alizarin crimson
40% permanent rose
1 drop cobalt blue
Water Level 4

ColorRecipes

COLORS USED

 Indian Red

Burnt Umber

Burnt Sienna

196. 100% Indian red
Water Level 1

197. 100% burnt umber
Water Level 1

198. 100% burnt sienna
Water Level 1

199. 100% Indian red
Water Level 2

200. 100% burnt umber
Water Level 2

201. 100% burnt sienna
Water Level 2

202. 100% Indian red
Water Level 3

203. 100% burnt umber
Water Level 3

204. 100% burnt sienna
Water Level 3

205. 100% Indian red
Water Level 4

206. 100% burnt umber
Water Level 4

207. 100% burnt sienna
Water Level 4

208. 100% Indian red
Water Level 5

209. 100% burnt umber
Water Level 5

210. 100% burnt sienna
Water Level 5

21

ColorRecipes

211. 100% permanent alizarin crimson
Water Level 1

212. 100% permanent alizarin crimson
Water Level 3

213. 100% permanent alizarin crimson
Water Level 5

214. 80% permanent alizarin crimson
20% cadmium yellow
Water Level 2

215. 85% permanent alizarin crimson
15% cadmium yellow
Water Level 3

216. 85% permanent alizarin crimson
15% cadmium yellow
Water Level 5

217. 40% permanent alizarin crimson
60% cadmium yellow
Water Level 2.5

218. 45% permanent alizarin crimson
55% cadmium yellow
Water Level 3

219. 50% permanent alizarin crimson
50% cadmium yellow
Water Level 5

220. 15% permanent alizarin crimson
85% cadmium yellow
Water Level 2.5

221. 40% permanent alizarin crimson
60% cadmium yellow
Water Level 3

222. 35% permanent alizarin crimson
65% cadmium yellow
Water Level 5

223. 3% permanent alizarin crimson
97% cadmium yellow
Water Level 3

224. 5% permanent alizarin crimson
95% cadmium yellow
Water Level 3

225. 10% permanent alizarin crimson
90% cadmium yellow
Water Level 5

 Vermilion

 Cadmium Red Light

 Yellow Ochre

226. 100% vermilion
Water Level 1

227. 100% cadmium red light
Water Level 1

228. 65% cadmium red light
35% yellow ochre
Water Level 1

229. 100% vermilion
Water Level 2

230. 100% cadmium red light
Water Level 2

231. 65% cadmium red light
35% yellow ochre
Water Level 2

232. 100% vermilion
Water Level 3

233. 100% cadmium red light
Water Level 3

234. 65% cadmium red light
35% yellow ochre
Water Level 3

235. 100% vermilion
Water Level 4

236. 100% cadmium red light
Water Level 4

237. 65% cadmium red light
35% yellow ochre
Water Level 4

238. 100% vermilion
Water Level 5

239. 100% cadmium red light
Water Level 5

240. 65% cadmium red light
35% yellow ochre
Water Level 5

ColorRecipes

241. 100% cadmium red light
Water Level 1

242. 100% cadmium red light
Water Level 3

243. 100% cadmium red light
Water Level 4

244. 70% cadmium red light
30% lemon yellow
Water Level 2

245. 80% cadmium red light
20% lemon yellow
Water Level 3

246. 75% cadmium red light
25% lemon yellow
Water Level 3.5

247. 45% cadmium red light
55% lemon yellow
Water Level 2

248. 60% cadmium red light
40% lemon yellow
Water Level 3

249. 65% cadmium red light
35% lemon yellow
Water Level 3.5

250. 25% cadmium red light
75% lemon yellow
Water Level 2

251. 35% cadmium red light
65% lemon yellow
Water Level 3

252. 40% cadmium red light
60% lemon yellow
Water Level 3.5

253. 10% cadmium red light
90% lemon yellow
Water Level 2

254. 15% cadmium red light
85% lemon yellow
Water Level 3

255. 20% cadmium red light
80% lemon yellow
Water Level 3.5

COLORS USED

⬤ Cadmium Orange
⬤ Lemon Yellow
⬤ Naples Yellow

256. 100% cadmium orange
Water Level 2

257. 100% cadmium orange
Water Level 3

258. 100% cadmium orange
Water Level 5

259. 60% lemon yellow
40% cadmium orange
Water Level 2

260. 45% lemon yellow
55% cadmium orange
Water Level 3

261. 55% lemon yellow
45% cadmium orange
1 drop Naples yellow
Water Level 4

262. 80% lemon yellow
20% cadmium orange
Water Level 2

263. 90% lemon yellow
10% cadmium orange
Water Level 3

264. 75% lemon yellow
25% cadmium orange
1 drop Naples yellow
Water Level 4

265. 100% lemon yellow
2 drops cadmium orange
Water Level 2

266. 100% lemon yellow
3 drops cadmium orange
Water Level 3

267. 85% lemon yellow
15% cadmium orange
1 drop Naples yellow
Water Level 3.5

268. 100% lemon yellow
1 drop cadmium orange
Water Level 2

269. 100% lemon yellow
2 drops cadmium orange
Water Level 3

270. 95% lemon yellow
5% cadmium orange
1 drop Naples yellow
Water Level 3

ColorRecipes

COLORS USED

 Cadmium Orange Sap Green

Cadmium Red Light

 Viridian Green

271. 75% cadmium orange
25% cadmium red light
Water Level 2

272. 75% cadmium orange
25% cadmium red light
Water Level 3

273. 75% cadmium orange
25% cadmium red light
Water Level 4

274. 100% recipe #271
1 drop viridian green
Water Level 2

275. 40% cadmium red light
35% sap green
20% viridian green
5% cadmium orange
Water Level 2.5

276. 35% cadmium red light
35% sap green
30% viridian green
Water Level 3

277. 50% sap green
50% recipe #274
Water Level 2

278. 20% cadmium red light
35% sap green
35% viridian green
10% cadmium orange
Water Level 3

279. 25% cadmium red light
35% sap green
40% viridian green
Water Level 3

280. 70% sap green
10% viridian green
20% cadmium orange
Water Level 2

281. 15% cadmium red light
40% sap green
25% viridian green
20% cadmium orange
Water Level 3

282. 15% cadmium red light
50% sap green
35% viridian green
Water Level 3.5

283. 70% sap green
5% viridian green
25% cadmium orange
Water Level 2

284. 90% recipe #280
10% viridian green
Water Level 3

285. 85% recipe #282
10% viridian green
5% cadmium orange
Water Level 4

COLORS USED

 Yellow Ochre

 Ultramarine Blue

Phthalo Blue

286. 100% yellow ochre
Water Level 1

287. 100% yellow ochre
1 drop ultramarine blue
Water Level 1

288. 70% yellow ochre
20% ultramarine blue
10% phthalo blue
Water Level 1

289. 100% yellow ochre
Water Level 2

290. 50% yellow ochre
50% ultramarine blue
1 drop phthalo blue
Water Level 2

291. 70% yellow ochre
25% ultramarine blue
5% phthalo blue
Water Level 2

292. 100% yellow ochre
Water Level 2.5

293. 50% yellow ochre
50% ultramarine blue
2 drops phthalo blue
Water Level 2.5

294. 70% yellow ochre
25% ultramarine blue
5% phthalo blue
Water Level 3

295. 100% yellow ochre
Water Level 3

296. 65% yellow ochre
35% ultramarine blue
Water Level 3

297. 75% yellow ochre
23% ultramarine blue
2% phthalo blue
Water Level 3

298. 100% yellow ochre
Water Level 4

299. 65% yellow ochre
35% ultramarine blue
Water Level 4

300. 70% yellow ochre
30% ultramarine blue
Water Level 4

ColorRecipes

COLORS USED	Naples Yellow	Yellow Ochre
	Cadmium Red Light	
	Burnt Sienna	

301. 100% Naples yellow
Water Level 1

302. 100% Naples yellow
1 drop cadmium red light
Water Level 1

303. 100% Naples yellow
1 drop cadmium red light
1 drop burnt sienna
Water Level 1

304. 100% Naples yellow
Water Level 2

305. 100% Naples yellow
2 drops cadmium red light
Water Level 2

306. 100% Naples yellow
2 drops cadmium red light
2 drops burnt sienna
Water Level 2.5

307. 100% Naples yellow
Water Level 2.5

308. 95% Naples yellow
5% cadmium red light
1 drop burnt sienna
Water Level 2.5

309. 90% Naples yellow
5% burnt sienna
5% yellow ochre
Water Level 3

310. 100% Naples yellow
1 drop burnt sienna
Water Level 3

311. 90% Naples yellow
5% cadmium red light
5% yellow ochre
1 drop burnt sienna
Water Level 3.5

312. 80% Naples yellow
10% burnt sienna
10% yellow ochre
Water Level 4

313. 98% Naples yellow
2% burnt sienna
Water Level 3.5

314. 95% Naples yellow
2% cadmium red light
3% burnt sienna
Water Level 4

315. 60% Naples yellow
30% burnt sienna
10% yellow ochre
Water Level 4

COLORS USED

Lemon Yellow

● Ivory Black

Lemon Yellow

320. 100% lemon yellow
Water Level 3.5

319. 100% lemon yellow
Water Level 2.5

318. 100% lemon yellow
Water Level 2

317. 100% lemon yellow
Water Level 1.5

316. 100% lemon yellow
Water Level 1

Water

Lemon Yellow

325. 90% lemon yellow
10% gray
Water Level 1

324. 85% lemon yellow
15% gray
Water Level 2

323. 80% lemon yellow
20% gray
Water Level 2.5

322. 60% lemon yellow
40% gray
Water Level 3

321. 50% lemon yellow
50% gray
Water Level 3.5

Gray

Lemon Yellow

330. 100% lemon yellow
1 drop ivory black
Water Level 2

329. 100% lemon yellow
3 drops ivory black
Water Level 2.5

328. 80% lemon yellow
20% ivory black
Water Level 3

327. 70% lemon yellow
30% ivory black
Water Level 3.5

326. 65% lemon yellow
35% ivory black
Water Level 4

Ivory Black

COLORS USED

● Cadmium Red Light
● Ivory Black

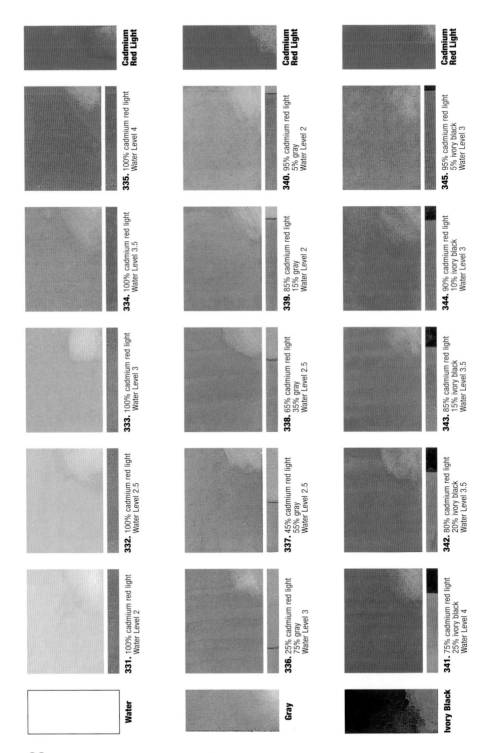

Cadmium Red Light

335. 100% cadmium red light
Water Level 4

334. 100% cadmium red light
Water Level 3.5

333. 100% cadmium red light
Water Level 3

332. 100% cadmium red light
Water Level 2.5

331. 100% cadmium red light
Water Level 2

Water

Cadmium Red Light

340. 95% cadmium red light
5% gray
Water Level 2

339. 85% cadmium red light
15% gray
Water Level 2

338. 65% cadmium red light
35% gray
Water Level 2.5

337. 45% cadmium red light
55% gray
Water Level 2.5

336. 25% cadmium red light
75% gray
Water Level 3

Gray

Cadmium Red Light

345. 95% cadmium red light
5% ivory black
Water Level 3

344. 90% cadmium red light
10% ivory black
Water Level 3

343. 85% cadmium red light
15% ivory black
Water Level 3.5

342. 80% cadmium red light
20% ivory black
Water Level 3.5

341. 75% cadmium red light
25% ivory black
Water Level 4

Ivory Black

COLORS USED

Cerulean Blue

Ivory Black

Cerulean Blue

350. 100% cerulean blue
Water Level 4

349. 100% cerulean blue
Water Level 3.5

348. 100% cerulean blue
Water Level 3

347. 100% cerulean blue
Water Level 2

346. 100% cerulean blue
Water Level 1

Water

Cerulean Blue

355. 90% cerulean blue
10% gray
Water Level 4

354. 85% cerulean blue
15% gray
Water Level 3.5

353. 80% cerulean blue
20% gray
Water Level 3

352. 75% cerulean blue
25% gray
Water Level 2

351. 65% cerulean blue
35% gray
Water Level 1

Gray

Cerulean Blue

360. 100% cerulean blue
1 drop ivory black
Water Level 4

359. 100% cerulean blue
2 drops ivory black
Water Level 3.5

358. 95% cerulean blue
5% ivory black
Water Level 3

357. 90% cerulean blue
10% ivory black
Water Level 3

356. 85% cerulean blue
15% ivory black
Water Level 2

Ivory Black

31

IntensityRecipes

COLORS USED

- Cadmium Yellow
- Cadmium Yellow Deep
- Cadmium Orange
- Dioxazine Violet
- Mauve
- Cerulean Blue

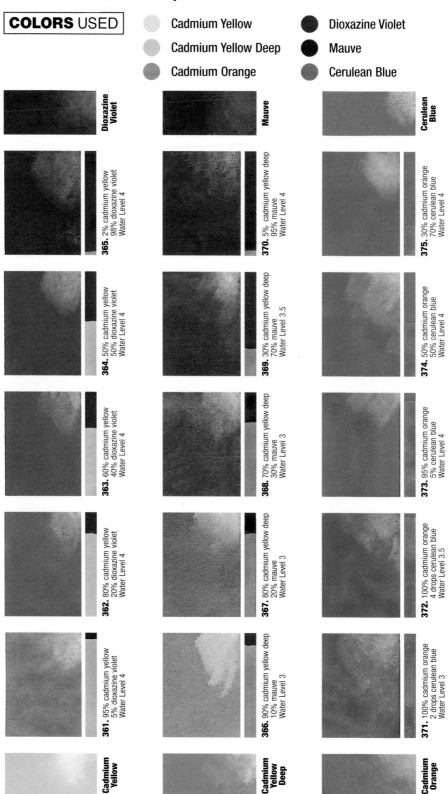

Dioxazine Violet

365. 2% cadmium yellow
98% dioxazine violet
Water Level 4

364. 50% cadmium yellow
50% dioxazine violet
Water Level 4

363. 60% cadmium yellow
40% dioxazine violet
Water Level 4

362. 80% cadmium yellow
20% dioxazine violet
Water Level 4

361. 95% cadmium yellow
5% dioxazine violet
Water Level 4

Cadmium Yellow

Mauve

370. 5% cadmium yellow deep
95% mauve
Water Level 4

369. 30% cadmium yellow deep
70% mauve
Water Level 3.5

368. 70% cadmium yellow deep
30% mauve
Water Level 3

367. 80% cadmium yellow deep
20% mauve
Water Level 3

366. 90% cadmium yellow deep
10% mauve
Water Level 3

Cadmium Yellow Deep

Cerulean Blue

375. 30% cadmium orange
70% cerulean blue
Water Level 4

374. 50% cadmium orange
50% cerulean blue
Water Level 4

373. 95% cadmium orange
5% cerulean blue
Water Level 4

372. 100% cadmium orange
4 drops cerulean blue
Water Level 3.5

371. 100% cadmium orange
2 drops cerulean blue
Water Level 3

Cadmium Orange

IntensityRecipes

COLORS USED

- Cadmium Red Light
- Perm. Alizarin Crimson
- Dioxazine Violet
- Hooker's Green
- Sap Green
- Cadmium Yellow Pale

Hooker's Green

380. 1 drop cadmium red light
100% Hooker's green
Water Level 3.5

379. 3 drops cadmium red light
100% Hooker's green
Water Level 3.5

378. 60% cadmium red light
40% Hooker's green
Water Level 3.5

377. 100% cadmium red light
2 drops Hooker's green
Water Level 3.5

376. 100% cadmium red light
1 drop Hooker's green
Water Level 3.5

Cadmium Red Light

Sap Green

385. 1 drop permanent alizarin crimson
100% sap green
Water Level 3

384. 2 drops permanent alizarin crimson
100% sap green
Water Level 3

383. 3 drops permanent alizarin crimson
100% sap green
Water Level 3

382. 15% permanent alizarin crimson
85% sap green
Water Level 3.5

381. 25% permanent alizarin crimson
75% sap green
Water Level 4

Permanent Alizarin Crimson

Cadmium Yellow Pale

390. 1 drop dioxazine violet
100% cadmium yellow pale
Water Level 4

389. 2 drops dioxazine violet
100% cadmium yellow pale
Water Level 4

388. 5% dioxazine violet
95% cadmium yellow pale
Water Level 4

387. 50% dioxazine violet
50% cadmium yellow pale
Water Level 4

386. 70% dioxazine violet
30% cadmium yellow pale
Water Level 4

Dioxazine Violet

33

PortraitColors

The following base-color mixtures can be used for an infinite number of flesh tones. Add water or a lighter-value color to lighten any mixture. Add various combinations of light, dark, or graying colors to these mixtures to create any skin color. And, of course, add water to thin any mixture. (Water lightens the value by allowing the white of the paper to show through the thinned color.)

The first mixture is a simple starter palette, beginning with a base mixture of yellow ochre and cadmium red light. Intermix them to various degrees of redness. Remember that this is simply a base color; it should rarely be used in its pure state because it is too harsh and raw. Some alternate base mixtures are shown at the bottom of the page. Use one or more of the suggested colors to make any of these base mixtures lighter, darker, or grayer to obtain the desired flesh color and value. For a more in-depth study on mixing watercolors for portraits, see Walter Foster's *Color Mixing Recipes for Portraits* (CRC3) by William F. Powell.

BASIC FLESH MIX
YELLOW OCHRE + CADMIUM RED LIGHT

TO LIGHTEN

To lighten the base mix, add water or one or more of the lighter colors listed below. (Other lighter colors can be used, but these work very well.) To create more delicate flesh tones, tint the colors by adding water.

Lemon yellow
Cadmium yellow pale
Cadmium yellow
Naples yellow
Cadmium orange

TO DARKEN

To darken the base mix, add one or more of the darker colors listed below. (Other darker colors can be used, but try these first.) To create a shade of a color tone, add a touch of ivory black.

Burnt umber
Burnt sienna
Permanent alizarin crimson
Ultramarine blue
Dioxazine violet

TO GRAY

To gray the basic mixture, add one or more of the mixes listed below. (Again, other colors also will work.) This flesh color is predominantly red, so also try adding a complementary color from the green family.

Viridian green
Sap green
Cadmium yellow + cerulean blue
Cadmium orange + ultramarine blue

A MODIFYING COLOR

*70% burnt umber +
30% permanent
alizarin crimson*

This dark reddish brown can be added to light flesh colors to tone them down, to reddish flesh colors to deepen and bronze them, and to shadow colors to warm them.

ALTERNATE BASE-COLOR MIXTURES

BURNT SIENNA +
CADMIUM RED LIGHT

NAPLES YELLOW +
VERMILION

BURNT UMBER +
VERMILION

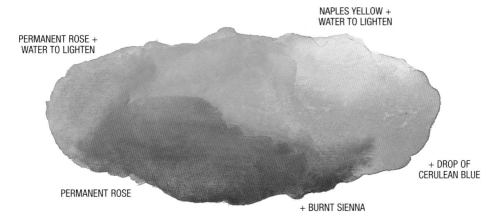

NAPLES YELLOW +
WATER TO LIGHTEN

PERMANENT ROSE +
WATER TO LIGHTEN

+ DROP OF
CERULEAN BLUE

PERMANENT ROSE

+ BURNT SIENNA

FAIR SKIN TONES

The combination of colors above is used for people with fair or delicate skin. With care, a great number of flesh values is possible. Permanent rose is the key color. Add water along with the other colors shown to change the value; gray and warm the color to create soft and light flesh tones. Try to keep the color mixes delicate—not too harsh or pure. (Note: Avoid using any red in its pure state when painting flesh.) Experiment with the colors shown, and then try developing some palettes of your own.

BLACK THROUGH BRONZE SKIN TONES

This palette can be used for skin tones that range in hue from black to bronze. Manipulate the colors and values to create various skin colors; the possibilities are endless. Notice that some black skin tones have a beautiful undertone of warm colors, whereas others are delicately cool. Watch for subtle colors that appear under various lighting conditions; look for delicate colors in the shadows and lively tints in the light areas and highlights. Depending on the model, the shadows can be warm or cool—even purple or green. To gray shadows, use mixtures of burnt umber plus ultramarine blue and/or burnt umber plus viridian green.

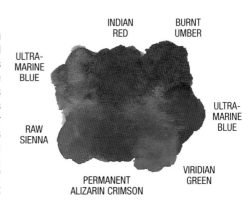

INDIAN RED

BURNT UMBER

ULTRA-MARINE BLUE

ULTRA-MARINE BLUE

RAW SIENNA

VIRIDIAN GREEN

PERMANENT ALIZARIN CRIMSON

LIGHT BRONZE SKIN TONES

These mixtures are starting formulae for bronze skins that are light to medium in value. These colors can be warmed with a drop of Indian red—but don't use too much or they will move away from the bronze and into red. There is a light side and dark side on this chart; any additional colors should be added to the proper value side. Experiment with these palettes, and remember that these introductory colors can lead to an endless number of flesh mixtures.

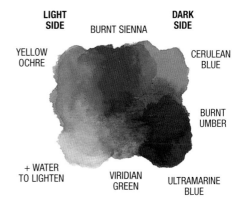

LIGHT SIDE

BURNT SIENNA

DARK SIDE

YELLOW OCHRE

CERULEAN BLUE

BURNT UMBER

+ WATER TO LIGHTEN

VIRIDIAN GREEN

ULTRAMARINE BLUE

PortraitColors

WARM AND COOL COLOR AREAS IN AND AROUND THE EYES AND MOUTH

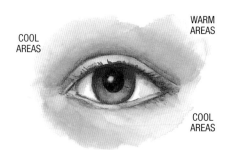

COOL
AREAS

WARM
AREAS

COOL
AREAS

Use the basic flesh mix (see page 34) + water,
burnt sienna, Indian red, Naples yellow, and viridian
green for the skin around the eye.

Lighting affects shadows and forms. The eyes here are lighted from the upper left; there are many subtle shadows and highlights in the flesh surrounding the eye. Some shadow colors are cool; others are warm (deep shadows usually are cooler). A pool of light often is caught in the iris, creating a liquid look. The surface light reflection in the eye should be painted softly. Leave the paper clean where the reflection will be, and then place a very subtle hint of pale blue, such as cerulean blue, on the outer edge. Leave the center free of paint for the brightest part of the highlight. Do not allow the white of eyes or teeth to remain pure white. Add a very pale tint of blue mixed with flesh to create a more natural color.

Use burnt umber and
burnt sienna for warm darks.

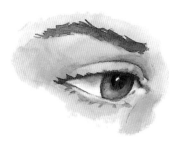

LIGHT GLOW:
YELLOW OCHRE
+ CADMIUM
ORANGE BASE
(HIGHLIGHTED
BY THINNING
WITH WATER)

IRIS:
BURNT UMBER
+ ULTRAMARINE
BLUE

WHITE OF EYE: WATER + DROP OF
FLESH MIX AND CERULEAN BLUE

The upper lip usually overhangs and casts a shadow on the lower lip. It should be painted just slightly darker than the lower lip. The edges of the lips should be soft so they do not appear to be "pasted on." Because the lower lip catches more light, highlight it a bit more than the upper one.

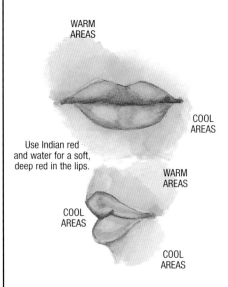

WARM
AREAS

COOL
AREAS

Use Indian red
and water for a soft,
deep red in the lips.

WARM
AREAS

COOL
AREAS

COOL
AREAS

Use the basic flesh mix (see page 34) +
permanent alizarin crimson. Add water to
lighten. Add burnt sienna or burnt umber to
darken and Indian red to warm.

A good variation of edges adds life and realism to the mouth. Some lines are soft and "lost," whereas others are hard and definite. Use a mix of burnt umber and permanent alizarin crimson for deep shadows, and add a drop of ultramarine blue for purples.

For lower lip highlights, use water and a pale pink mix—do not leave the pure white paper showing because it will appear too shiny. Indian red plus a drop of cadmium red light (thinned with water) makes a good natural pink. Naples yellow plus a drop of pink (thinned with water) makes a good highlight. Permanent alizarin crimson thinned with water makes a good cool pink; cadmium red light or vermilion thinned with water makes a warm pink. Try not to make lips too red; a natural look is far more desirable. Do, however, add a bit more color to the lips if the model wears makeup.

There are many reds that can be used for flesh and mouth colors. Use a mirror and practice painting your own mouth.

WARM AND COOL COLOR AREAS IN AND AROUND THE NOSE AND EARS

Many delicate color changes can take place on the ears and nose. The tops of ears sometimes can turn very red with the flow of blood. Similarly, the nose can become quite red at the tip. Colors selected for these areas should be muted in intensity. Vermilion and Indian red are a bit more muted than cadmium red light and are good colors to add to the basic flesh mix (see page 35) for this purpose. If necessary, add a touch of a brighter red to create a more lively pink. For shadowed areas, use delicate purple tones. Purples should be in the red range—if they are bluish, they will appear to be bruises.

Try not to allow any areas of noses or ears to become too intense with bright colors. Bright colors make ears and noses appear garish, distracting the viewer. Moreover, bright colors can make ears and noses appear larger than they are.

Begin by blocking in the masses and planes before going on to final blending. Apply a thin, very pale wash of water and Indian red; then use a light value of the basic flesh mix (see page 35) to build the values in and around the ears and nose. Make highlights by lifting color from the paper using a damp "thirsty" brush; then blot.

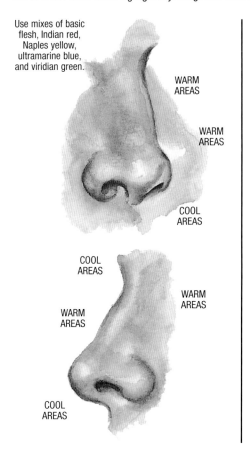

Use mixes of basic flesh, Indian red, Naples yellow, ultramarine blue, and viridian green.

WARM AREAS

WARM AREAS

COOL AREAS

COOL AREAS

WARM AREAS

WARM AREAS

COOL AREAS

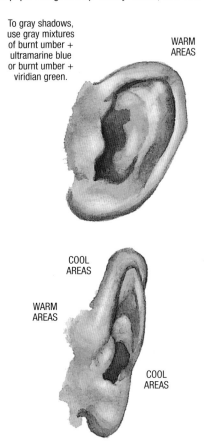

To gray shadows, use gray mixtures of burnt umber + ultramarine blue or burnt umber + viridian green.

WARM AREAS

COOL AREAS

COOL AREAS

WARM AREAS

WARM AREAS

COOL AREAS

FEATURES AND PROPORTION

Placing the mouth, eyes, and nose in proper relationship to one another on the cranial mass is of the utmost importance for establishing the likeness of your subject. For instance, the slightest variation of the position of the mouth between the bottom of the nose and the chin can change the entire expression of the portrait. Try painting a self-portrait using a mirror to practice accurate placement of features relative to one another. (Use a reversing mirror to see yourself as others do.)

ColorGuidanceIndex

39

ColorGuidanceIndex

ColorGuidanceIndex

ColorGuidanceIndex

ColorGuidanceIndex

LEGEND

◯ Lighten by adding more water than listed in the color mix

◉ Lighten slightly by adding a bit more water to the color mix

● Deepen by using less water and more of the darkest color in the mix

ColorGuidanceIndex

ColorGuidanceIndex

Lighten by adding more water than listed in the color mix

Lighten slightly by adding a bit more water to the color mix

Deepen by using less water and more of the darkest color in the mix

LEGEND

 Lighten by adding more water than listed in the color mix

 Lighten slightly by adding a bit more water to the color mix

⚫ Deepen by using less water and more of the darkest color in the mix

About the Author

 William F. Powell is an internationally recognized artist and one of America's foremost colorists. A native of Huntington, West Virginia, Bill studied at the Art Student's Career School in New York; Harrow Technical College in Harrow, England; and the Louvre Free School of Art in Paris, France. He has been professionally involved in fine art, commercial art, and technical illustrations for more than 45 years. His experience as an art instructor includes oil, watercolor, acrylic, colored pencil, and pastel—with subjects ranging from landscapes to portraits and wildlife. He also has authored a number of art instruction books including several popular Walter Foster titles.

As a renowned master of color, Bill has conducted numerous "Color Mixing and Theory" workshops in various cities throughout the U.S. His expertise in color theory also led him to author and illustrate several articles and an educational series of 11 articles entitled "Color in Perspective" for a national art magazine. Bill also has performed as an art consultant for national space programs and for several artists' paint manufacturers. His work has included the creation of background sets for films, model making, animated cartoons, and animated films for computer mockup programs. He also produces instructional painting, color mixing, and drawing art videos.